Exploration

of

White

Cherie Bodenstab

Healing Drumming for Recovery

BALBOA.
PRESS

A DIVISION OF HAY HOUSE

Balboa Press books may be ordered through booksellers or by contacting:

Balboa Press
A Division of Hay House
1663 Liberty Drive
Bloomington, IN 47403
www.balboapress.com
1 (877) 407-4847

Print information available on the last page.

ISBN: 978-1-5043-5775-3 (sc)
ISBN: 978-1-5043-5777-7 (hc)
ISBN: 978-1-5043-5776-0 (e)

Library of Congress Control Number: 2016907919

Balboa Press rev. date: 06/06/2016

Exploration of White
What does that mean to you?
We are unique individuals and the
meaning will be different for all.

The depth of conversation and exploration
of ones self, can be felt within
each individual who decides to take the
opportunity and write what this statement means
to them.

This is a journal of discovery, to keep on your
coffee table and have your guest write,
draw, doodle freely what the "Exploration
of White" means to them.

What does the "Exploration of White" mean to me?
Peace, purity, finding oneself, love, friendship,
all colors, energy, self-discovery.

Enjoy!

Cherie Bodenstab
www.healingdrummingforrecovery.com

Peace

Purity,

Clarity

Love

What is your definition of Exploration of White

<u>Date:</u>

<u>Author:</u>

What is your definition of Exploration of White

Date:

Author:

What is your definition of Exploration of White

Date:

Author:

What is your definition of
Exploration of White

Date:

Author:

What is your definition of
Exploration of White

Date:

Author:

What is your definition of Exploration of White

Date:

Author:

What is your definition of Exploration of White

Date:

Author:

What is your definition of Exploration of White

Date:

Author:

What is your definition of Exploration of White

Date:

Author:

What is your definition of Exploration of White

Date:

Author:

What is your definition of
Exploration of White

Date:

Author:

Exploration
of White

Exploration
of White

Exploration
of White

What is your definition of Exploration of White

Date:

Author:

<u>What is your definition of</u>
<u>Exploration of White</u>

<u>Date:</u>

<u>Author:</u>

What is your definition of
Exploration of White

Date:

Author:

What is your definition of
Exploration of White

Date:

Author:

What is your definition of Exploration of White

Date:

Author:

What is your definition of
Exploration of White

Date:

Author:

What is your definition of Exploration of White

Date:

Author:

What is your definition of
Exploration of White

Date:

Author:

What is your definition of
Exploration of White

Date:

Author:

What is your definition of
Exploration of White

Date:

Author:

What is your definition of
Exploration of White

Date:

Author:

Unlimited possibilities

What is your definition of
Exploration of White

Date:

Author:

What is your definition of Exploration of White

Date:

Author:

What is your definition of Exploration of White

Date:

Author:

What is your definition of
Exploration of White

Date:
Author:

What is your definition of Exploration of White

<u>Date:</u>

<u>Author:</u>

What is your definition of
Exploration of White

Date:

Author:

What is your definition of
Exploration of White

Date:

Author:

What is your definition of
Exploration of White

Date:

Author:

What is your definition of
Exploration of White

Date:

Author:

What is your definition of
Exploration of White

Date:

Author:

What is your definition of
Exploration of White

Date:

Author:

Energy

Energy

Energy

What is your definition of
Exploration of White

Date:

Author:

What is your definition of
Exploration of White

Date:

Author:

What is your definition of
Exploration of White

<u>Date:</u>

<u>Author:</u>

What is your definition of
Exploration of White

Date:
Author:

What is your definition of
Exploration of White

Date:

Author:

What is your definition of Exploration of White

<u>Date:</u>
<u>Author:</u>

What is your definition of
Exploration of White

Date:

Author:

What is your definition of
Exploration of White

Date:

Author:

What is your definition of Exploration of White

Date:

Author:

What is your definition of Exploration of White

Date:

Author:

What is your definition of
Exploration of White

Date:

Author:

White as a Color is all Colors

What is your definition of
Exploration of White

Date:

Author:

What is your definition of Exploration of White

Date:

Author:

What is your definition of
Exploration of White

Date:

Author:

What is your definition of
Exploration of White

Date:

Author:

What is your definition of
Exploration of White

Date:

Author:

What is your definition of Exploration of White

Date:

Author:

What is your definition of
Exploration of White

Date:
Author:

What is your definition of Exploration of White

Date:

Author:

What is your definition of
Exploration of White

Date:

Author:

What is your definition of
Exploration of White

Date:

Author:

What is your definition of
Exploration of White

Date:

Author:

White
as a
pigment
is
Not a color

What is your definition of
Exploration of White

Date:

Author:

What is your definition of
Exploration of White

Date:
Author:

What is your definition of
Exploration of White

Date:

Author:

What is your definition of
Exploration of White

Date:

Author:

What is your definition of Exploration of White

Date:

Author:

What is your definition of
Exploration of White

Date:

Author:

What is your definition of Exploration of White

Date:

Author:

What is your definition of Exploration of White

<u>Date:</u>

<u>Author:</u>

What is your definition of Exploration of White

Date:

Author:

What is your definition of
Exploration of White

Date:

Author:

What is your definition of
Exploration of White

Date:

Author:

Honesty

Grateful

Kind

What is your definition of
Exploration of White

Date:

Author:

What is your definition of Exploration of White

Date:

Author:

What is your definition of
Exploration of White

Date:

Author:

What is your definition of
Exploration of White

Date:

Author:

What is your definition of
Exploration of White

Date:
Author:

What is your definition of Exploration of White

<u>Date:</u>
<u>Author:</u>

What is your definition of
Exploration of White

Date:

Author:

What is your definition of
Exploration of White

Date:

Author:

What is your definition of
Exploration of White

Date:

Author:

What is your definition of
Exploration of White

Date:

Author:

What is your definition of
Exploration of White

Date:

Author:

Beauty
is in the
Eye
of the
Beholder

What is your definition of Exploration of White

Date:

Author:

What is your definition of
Exploration of White

Date:

Author:

What is your definition of Exploration of White

Date:

Author:

What is your definition of
Exploration of White

Date:

Author:

What is your definition of Exploration of White

Date:

Author:

What is your definition of
Exploration of White

<u>Date:</u>

<u>Author:</u>

What is your definition of
Exploration of White

Date:

Author:

What is your definition of
Exploration of White

Date:

Author:

What is your definition of
Exploration of White

Date:

Author:

What is your definition of Exploration of White

Date:

Author:

What is your definition of
Exploration of White

Date:

Author:

Blessings

Blessings

Blessings

What is your definition of
Exploration of White

<u>Date:</u>

<u>Author:</u>

What is your definition of
Exploration of White

<u>Date:</u>

<u>Author:</u>

What is your definition of
Exploration of White

<u>Date:</u>

<u>Author:</u>

What is your definition of
Exploration of White

Date:

Author:

What is your definition of
Exploration of White

Date:

Author:

What is your definition of
Exploration of White

Date:

Author:

What is your definition of Exploration of White

Date:

Author:

What is your definition of
Exploration of White

Date:

Author:

What is your definition of
Exploration of White

Date:

Author:

What is your definition of Exploration of White

Date:

Author:

What is your definition of
Exploration of White

Date:

Author:

NAMASTE

NAMASTE

NAMASTE

What is your definition of
Exploration of White

Date:

Author:

What is your definition of Exploration of White

<u>Date:</u>

<u>Author:</u>

What is your definition of
Exploration of White

Date:

Author:

What is your definition of
Exploration of White

Date:

Author:

What is your definition of
Exploration of White

Date:

Author:

And
So it is
Peace and
Love!

Printed in the United States
By Bookmasters